BUXTON
HISTORY TOUR

ABOUT THE AUTHOR

Alan Roberts had an interesting career as a research scientist at a government laboratory on the outskirts of Buxton and he spent a lot of his spare time walking on the hills around the town. These interests combined to lead him to an interest in landscape history and he has written books on coal mines, quarries, turnpike roads, watermills, secretive military bases and prisoner-of-war camps in the surrounding countryside.

First published 2020

Amberley Publishing
The Hill, Stroud,
Gloucestershire, GL5 4EP
www.amberley-books.com

Copyright © Alan Roberts, 2020
Map contains Ordnance Survey data
© Crown copyright and database
right [2020]

ISBN 978 1 3981 0241 5 (print)
ISBN 978 1 3981 0242 2 (ebook)

British Library Cataloguing in
Publication Data.
A catalogue record for this book is
available from the British Library.

Origination by Amberley Publishing.
Printed in Great Britain.

INTRODUCTION

Buxton is situated on the Derbyshire Wye, in the Peak District. The town centre is at around 1,000 feet, making it one of the highest towns in England. The key feature in the development of Buxton from a small isolated village to a town of more than 20,000 people was the existence of warm mineral water springs in the valley close to the Wye. These springs were known to the Romans and healing powers were attributed to the springs during the medieval period. Their fame began to grow when Buxton Hall was built adjacent to the springs for the Earl of Shrewsbury in 1572.

At that time, apart from the two or three buildings near to the springs, Buxton was on the high ground, around the present-day Market Place area. Similarly, the neighbouring village of Fairfield was located on the high ground on the other side of the Wye Valley.

In the 1780s, the magnificent Crescent was constructed for the Duke of Devonshire, adjacent to Buxton Hall, and town houses, apartments, shops, spa facilities, a theatre and other entertainment facilities followed as the fashionable Georgian scene came to town.

The present layout of the town developed around roads built as turnpikes, 1724–1821, which reduced Buxton's isolation. The town continued to develop during Victoria's reign and a boost to the town's growth came in 1863 with the arrival of railway connections to London and to Manchester, with two adjacent stations close to the town centre.

Several large hotels and hydropathic establishments were constructed as well as many spacious villas set in large plots and the town expanded out from the narrow valley. Spring Gardens developed as the main shopping street. Entertainment facilities increased with the opening of the Pavilion Gardens, which by 1875 had 23 acres of landscaped park, a range of concert halls, a ballroom and a theatre. This was followed by the opening of the Opera House in 1903. Extensive tree planting took place on the hills closest to the town and these areas are now mature woodlands forming an attractive backdrop to the town.

These factors left a wealth of historic buildings related to the spa's development grouped together in the centre of the town, with other residential and commercial parts of the town on the higher ground. Several restoration projects on listed buildings have taken place in recent years and the largest of these, the Crescent (Grade I listed), is scheduled for completion in spring 2020.

KEY

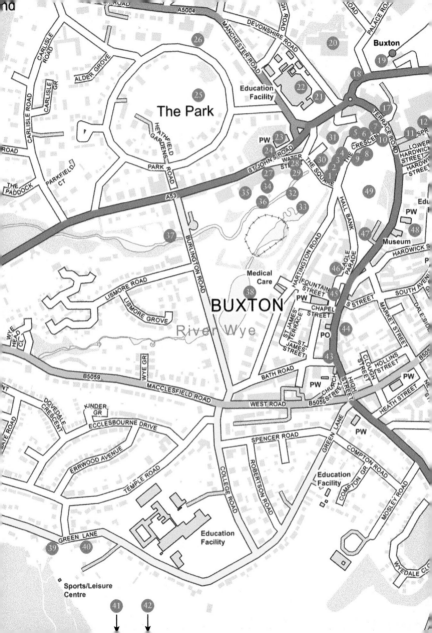

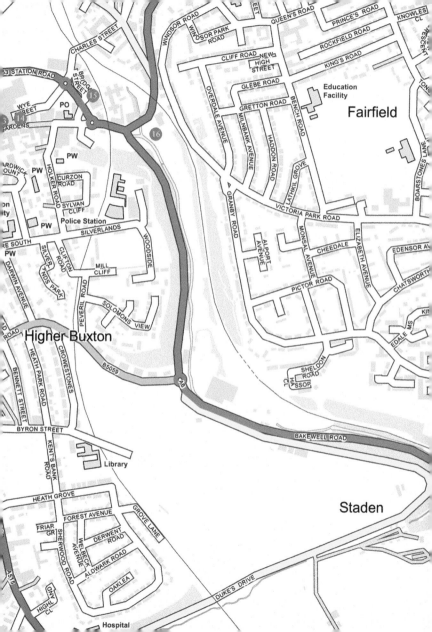

1. BUXTON HALL

The tour begins by the mineral water springs that led to Buxton's development as a spa. Buxton Hall was built in the 1570s for the Earl of Shrewsbury, who was at that time the custodian of Mary, Queen of Scots during her period of imprisonment. Buxton Hall was located on the banks of the Wye, adjacent to the mineral water springs which were famed for their therapeutic properties. Mary stayed at Buxton Hall for several weeks during 1576–78, seeking treatment for her rheumatism. The springs also supplied St Anne's Well with drinking water.

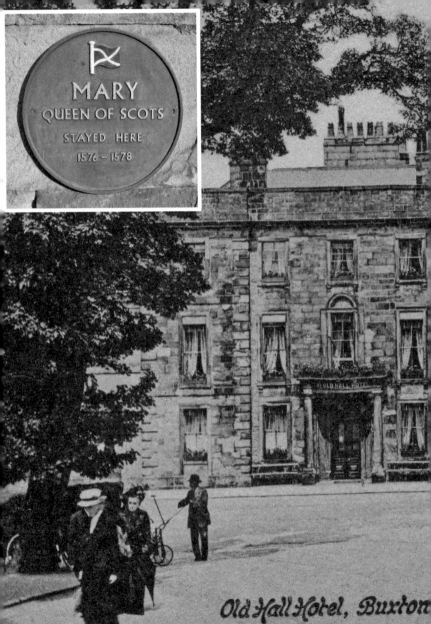

MARY
QUEEN OF SCOTS
STAYED HERE
1576 – 1578

Old Hall Hotel, Buxton

2. OLD HALL HOTEL

The present-day building of the Old Hall Hotel incorporates the original Buxton Hall building, which was greatly extended in 1670 to meet the increasing demand for treatments at the mineral water springs. The hotel has been in constant use since then and is regarded as England's oldest hotel. The walls and other features of the earlier hall building were identified within the present structure during a 1990s investigation.

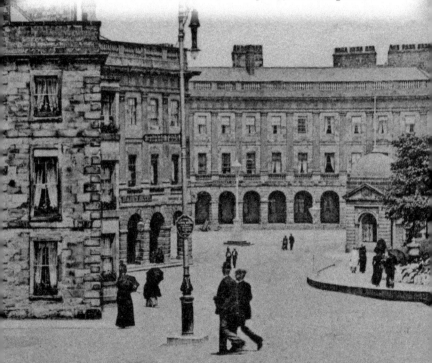

79452 J.V.

3. NATURAL MINERAL BATHS

The mineral water springs emerge adjacent to the Old Hall and there has been a succession of baths on this site since Roman times. The present Natural Mineral Baths were rebuilt in 1851–52, with two ladies' private baths, two gentlemen's private baths, a public bath and a charity bath. The baths were fed by the spring water and, as well as bathing in the waters, visitors could also receive treatments for various conditions. The baths were again altered in 1923–24 when the present entrance on to the Crescent replaced one at the rear of the building.

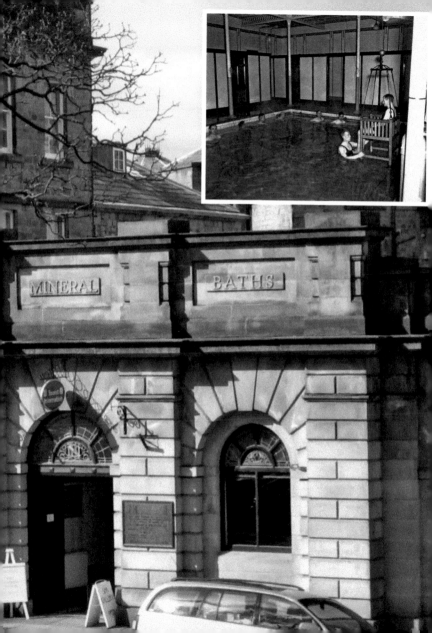

MINERAL BATHS

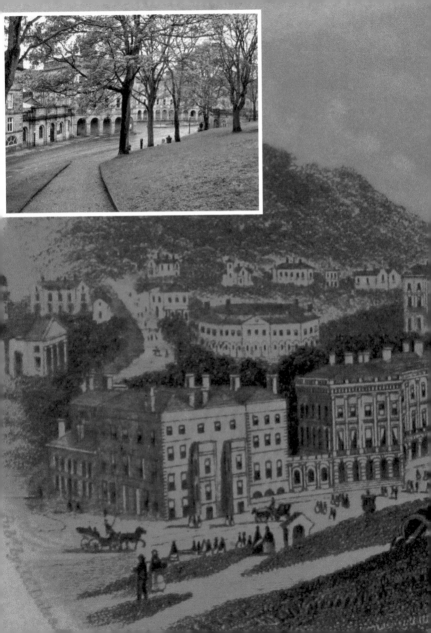

4. THE CRESCENT

The major development in the area was the construction of the Crescent for the Duke of Devonshire in the 1780s, close to Buxton Hall. The building is noted for its elegant exterior design and its detailed internal decoration. The architect of the Crescent was John Carr of York. In its original form, the Crescent consisted of two hotels, a town house and shops at the colonnade level. The restoration of this Grade I listed building is scheduled for completion in 2020 when it will establish a five-star hotel with spa treatments and a swimming pool.

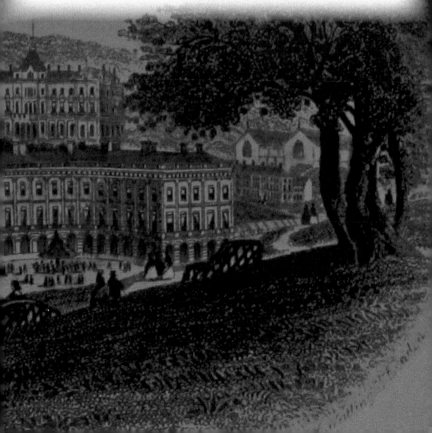

5. THE ASSEMBLY ROOM

An outstanding feature of the Crescent is the room shown in the photo, located in the east wing of the Crescent. Known as the Assembly Room, it is here laid out as the dining room of the Crescent Hotel. After that hotel closed, this end of the building was used as a hospital annex until 1963. Later, Buxton's public library was housed in this room for several years, which made each visit an impressive one.

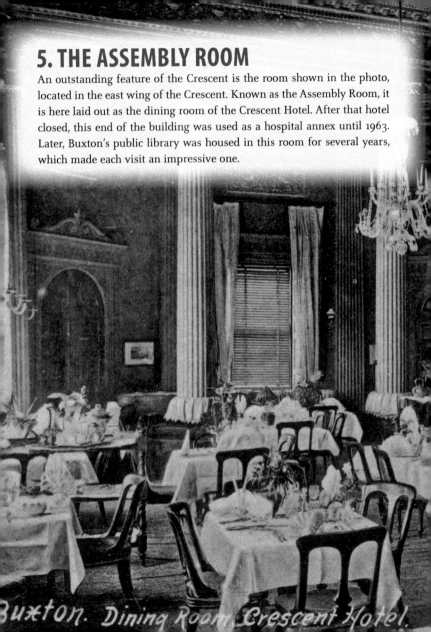

Buxton. Dining Room, Crescent Hotel.

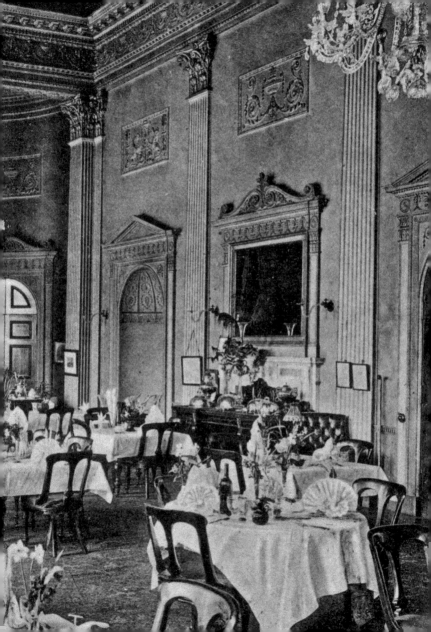

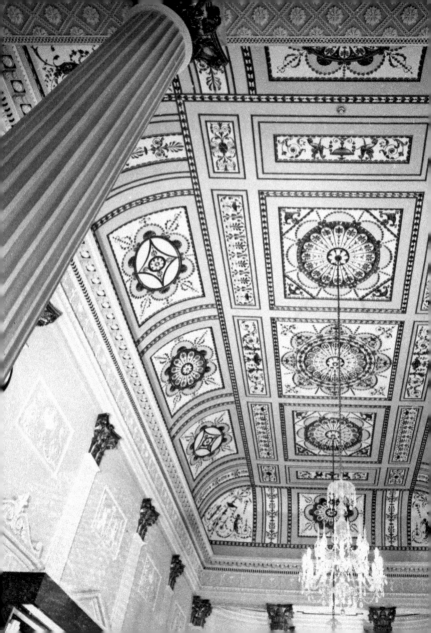

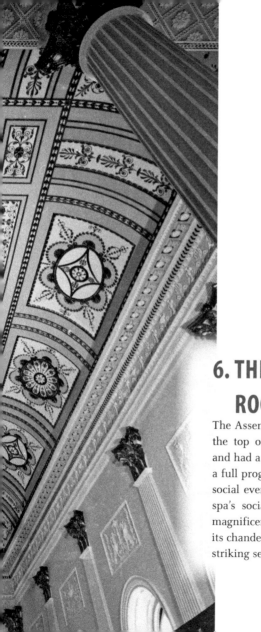

6. THE ASSEMBLY ROOM CEILING

The Assembly Room was located at the top of an impressive staircase and had a card room attached. With a full programme of balls and other social events, it was the hub of the spa's social season, for which the magnificent Adam-style ceiling and its chandeliers would have created a striking setting.

7. THERMAL BATHS

These baths were built in 1853, adjacent to the east wing of the Crescent and rebuilt in 1900. They provided a range of specialist hydrotherapy and massage treatments in individual small rooms until their closure in 1963. After a period of intermittent use, the building was converted into the Cavendish Arcade with a good range of small specialist shops.

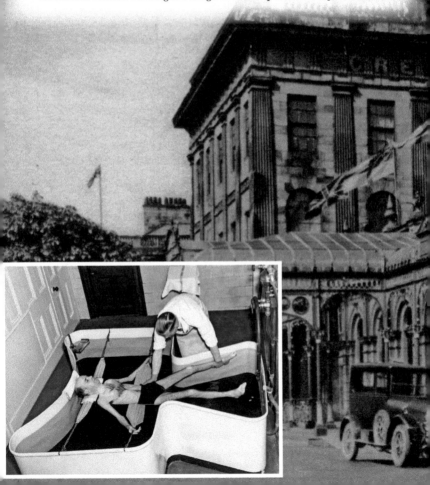

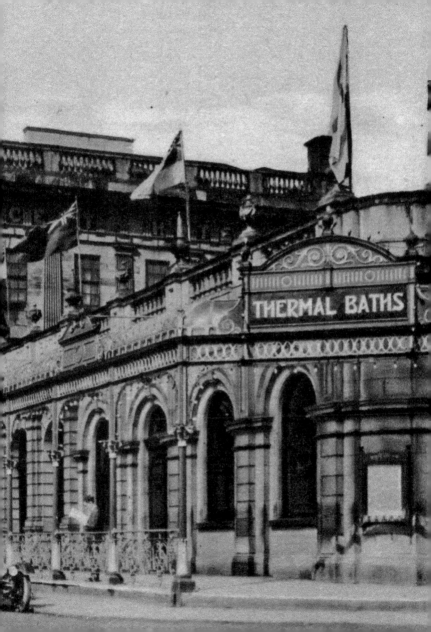

8. PUMP ROOM

The Pump Room was built opposite the Crescent in 1894. Originally, the arches at the front of the Pump Room were open, as with the Crescent, but they were later filled in. Mineral water from the springs was piped into the Pump Room and here visitors would pay to take the water served by an attendant from the marble basin in the floor. Tables and chairs provided a social area for visitors. Restoration of the building was completed in 2019 and it now houses the Buxton Visitor Centre.

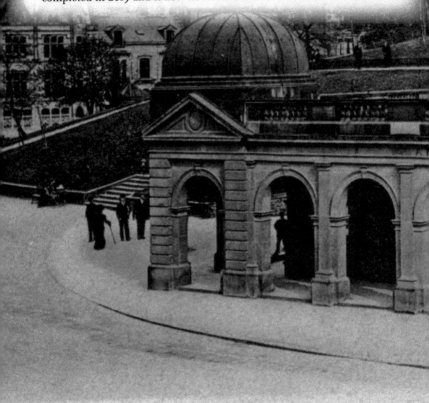

Room and Slopes. BUXTON.

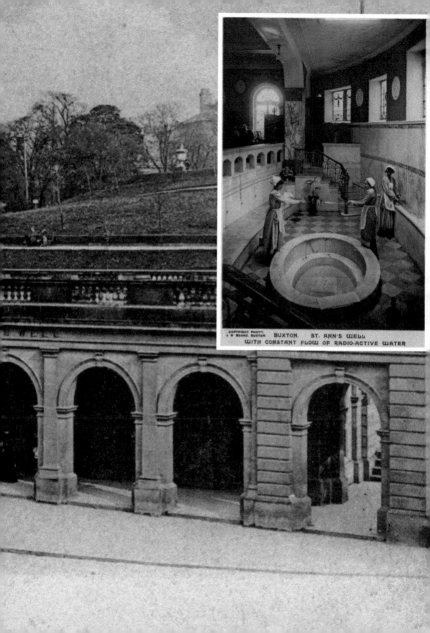

COPYRIGHT PHOTO.
& B BOARD, BUXTON.

BUXTON. ST. ANN'S WELL
WITH CONSTANT FLOW OF RADIO-ACTIVE WATER

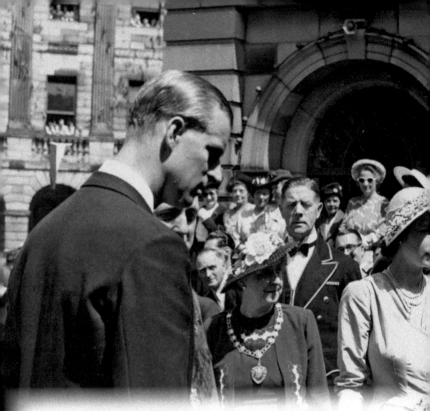

9. WELL DRESSING

St Anne's Well has had several sites over the centuries and it is now located next to the Pump Room. An Act of Parliament requires that there should be a free supply of water from the springs to inhabitants of Buxton and this comes from St Anne's Well. The tradition of dressing wells with floral decorations goes back a long way in Derbyshire, representing a celebration for the supply of clean water from the times when such supplies were hard to find. For Buxton, well dressing began in the mid-nineteenth century and three wells are dressed each year. The Queen (when Princess Elizabeth) with Prince Philip visited the well dressing at St Anne's Well in 1949.

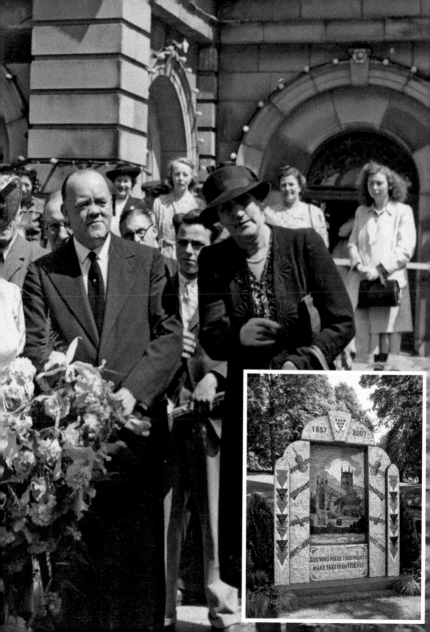

1857 2007

GOD WHO MADE THEE MIGHTY
MAKE THEE MIGHTIER YET

10. TURNER'S MEMORIAL

The large memorial, named after Samuel Turner who died in 1876, stands close to the junction of the Crescent, the Quadrant, Terrace Road and Spring Gardens, which is the main shopping centre in the town. The white building is the Grove Hotel, an eighteenth-century coaching inn. The memorial was severely damaged by a runaway vehicle coming down Terrace Road but its restoration has recently been completed.

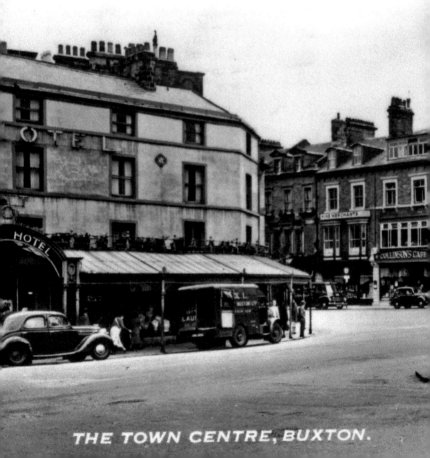

THE TOWN CENTRE, BUXTON.

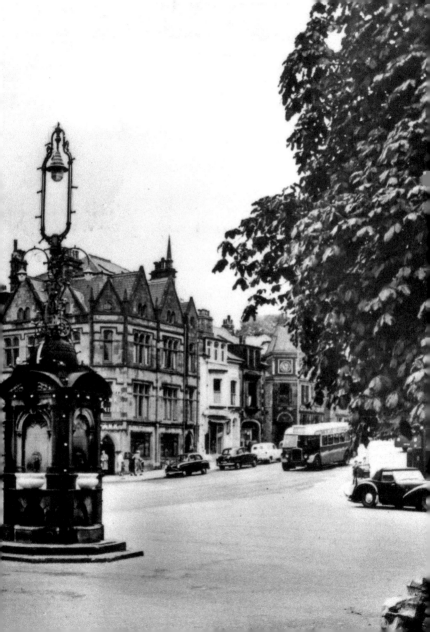

THE BUXTON

BURGO...

THE BAR

...NS GARDENS FROM THE SLOPES

11. SPRING GARDENS

Crossing Terrace Road from Turner's Memorial takes one into Spring Gardens. Originally the turnpike road to Sheffield, Spring Gardens has a varied range of buildings from the early nineteenth century to the late twentieth century and a good mixture of both independent and national shops and cafés. It was pedestrianised when Station Road was built following the closure of one of Buxton's railway stations.

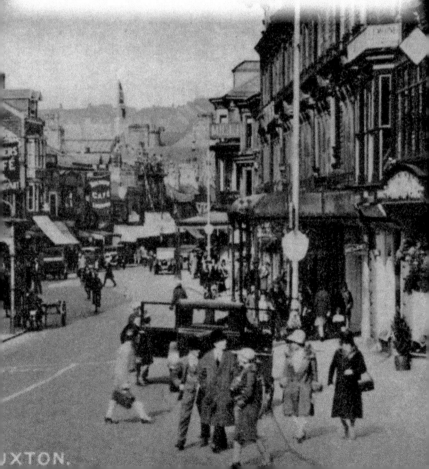

12. ROYAL HOTEL

The Royal Hotel was built in 1849–51 on the site of the former Angel Inn, and the building has had various uses over the years. The Springs Shopping Centre was constructed in the 1970s with its main entrance next to this building and it houses a useful variety of shops tucked away behind the shops on Spring Gardens itself. Part of the shopping centre is built across the River Wye.

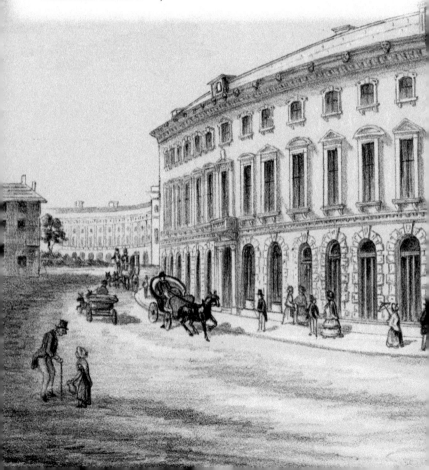

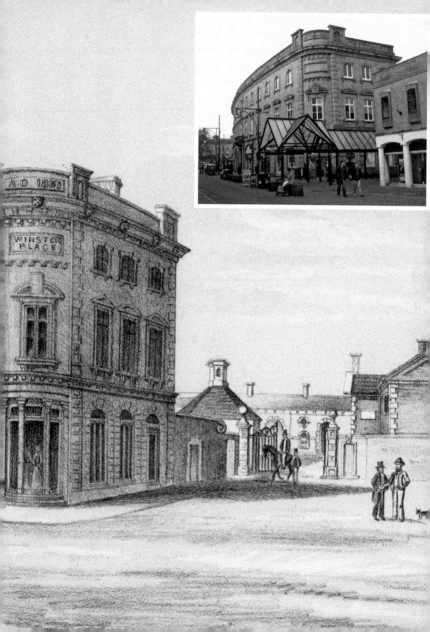

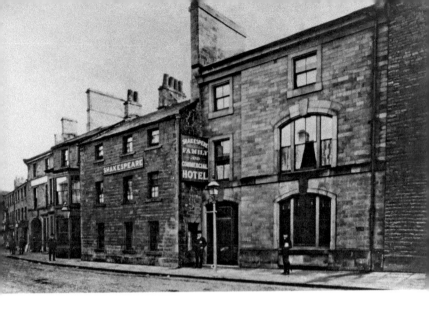

13. SHAKESPEARE HOTEL

The Shakespeare Hotel was built in 1711 close to where the earliest theatre in Buxton is thought to have been located, hence the hotel's name. The site was redeveloped by Woolworths in 1926 and, following that firm's closure, it was taken over by an outdoor pursuits shop. The arch that led to the hotel's stable yard is still in place, now leading to the Shakespeare Garage.

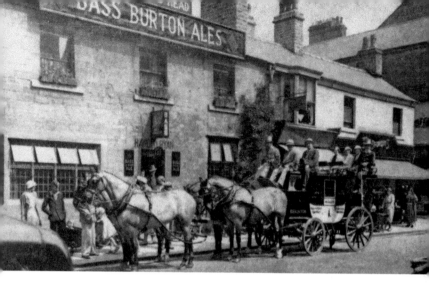

14. MILTON'S HEAD

This row of buildings is of early nineteenth-century origins and, externally, it has largely escaped the twentieth-century rebuilding of much of Spring Gardens. The photo shows a 1930s horse-drawn excursion outside the Milton's Head. The exterior of the building appears largely unchanged today.

15. RAILWAY HOTEL

The two Buxton stations opened in 1863 and the Railway Hotel opened shortly afterwards in Bridge Street at the end of Spring Gardens. In 1901, a third line from the stations was constructed, from Buxton to Ashbourne, which required a large thirteen-arch viaduct across the Wye Valley. This ran behind the Railway Hotel, as shown in the modern photo. A more recent arrival is a hall of residence for the University of Derby, which opened in 2007 and can be seen behind the viaduct.

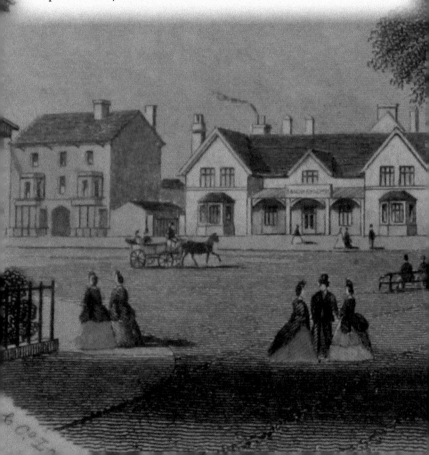

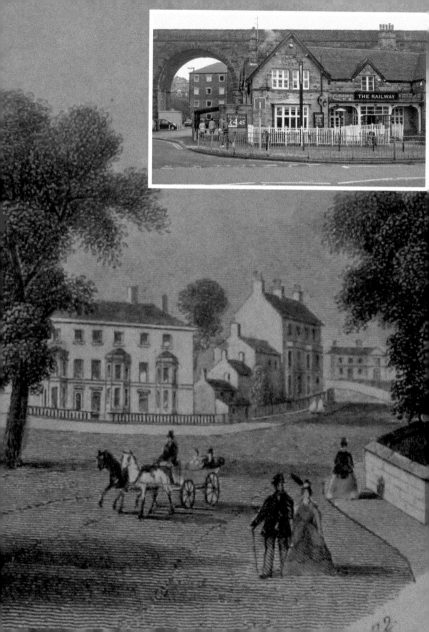

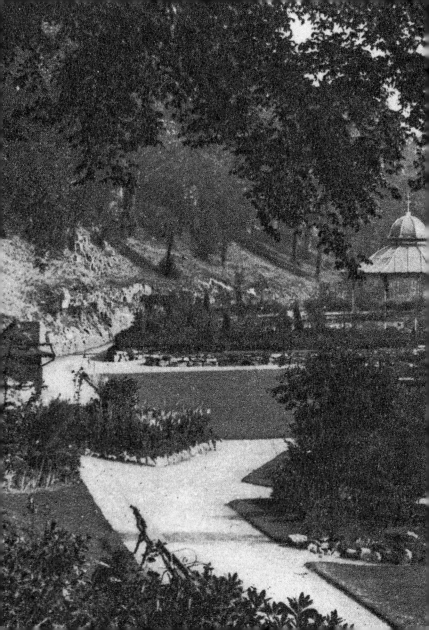

16. ASHWOOD PARK

The traditional routes into Buxton came across the high ground but in 1810 a new route was created for the Duke of Devonshire along the narrow confines of the Wye Valley (present A6 road), which linked Chatsworth and Buxton along a landscaped route. The railway link to London also came along the valley in 1863. This valley forms an important historic and scenic route to Buxton. At the far end of the park is a weir close to the site of a watermill that served the ancient villages of Buxton and Fairfield as far back as the fourteenth century.

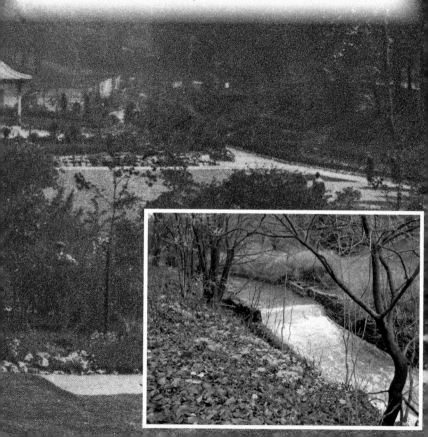

17. THE QUADRANT

Returning along Spring Gardens takes one to the Quadrant, which leads uphill in a curving line from the Grove Hotel (awaiting restoration). The view from the Slopes shows the Thermal Baths, the Grove Hotel and the Quadrant, before the railway stations were built. The more recent photo shows additional buildings between the Grove Hotel and the Quadrant and the surviving station in the gap between them.

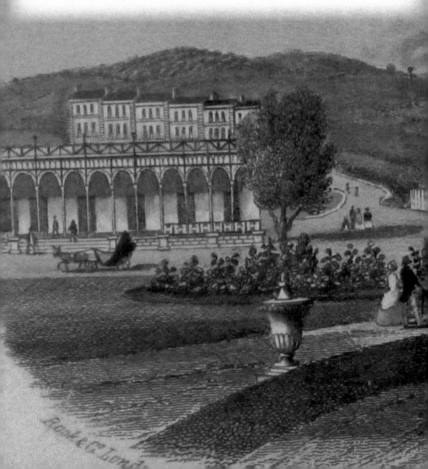

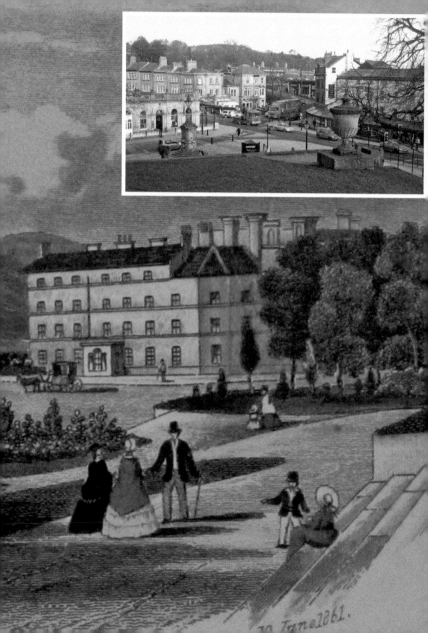

19 June 1861.

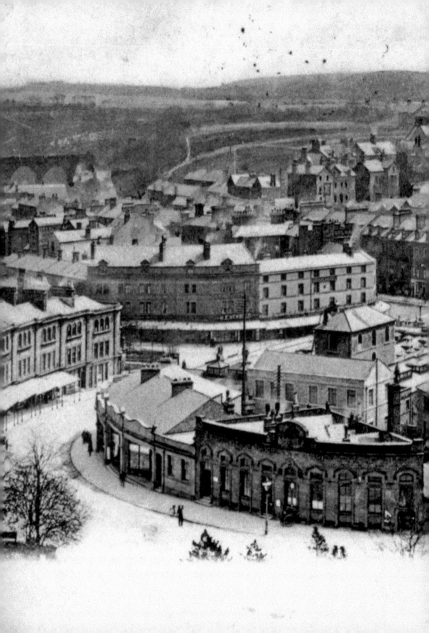

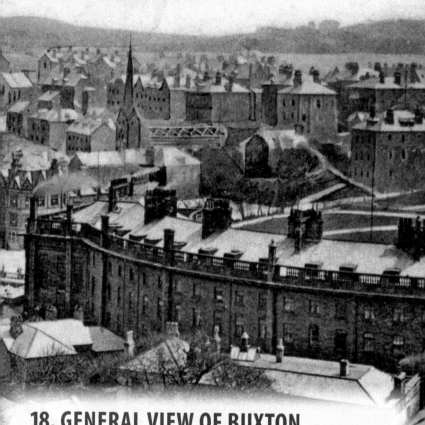

18. GENERAL VIEW OF BUXTON

In this view of the Quadrant, taken from near the station, it curves round behind the back of the Crescent with an elegant row of three-storey stone buildings to the left and an interesting variety of Victorian buildings, including the former post office to the right. Nowadays, Station Road, a relief road constructed following the closure of one of the local railway stations in 1968, enters from the left at a mini roundabout.

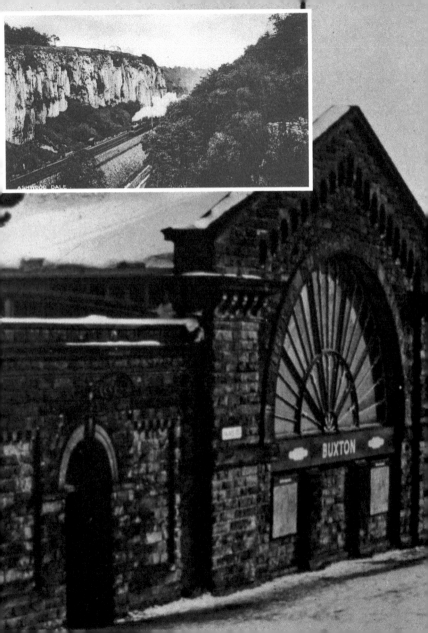

ASHWOOD DALE

BUXTON

19. THE RAILWAY STATIONS

The railway era arrived in Buxton when twin stations were opened in 1863. In the main photo, the nearer building was the station for the line from Buxton to Manchester, which is still in use. The further building was the station for the line from Buxton to London, St Pancras, via Millers Dale and Matlock, which was demolished following closure of the line to passenger traffic in 1968. The other photo shows a steam train on the line from Millers Dale, travelling towards Buxton along Ashwood Dale where the River Wye, the A6 road and the railway are confined within the narrow dale.

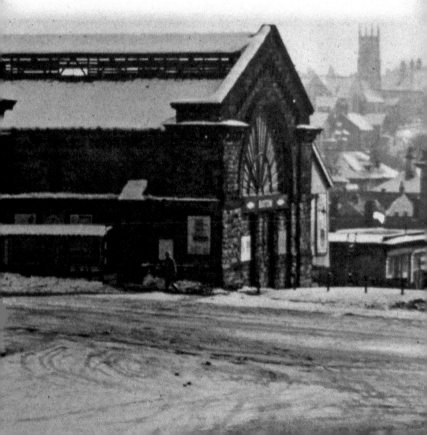

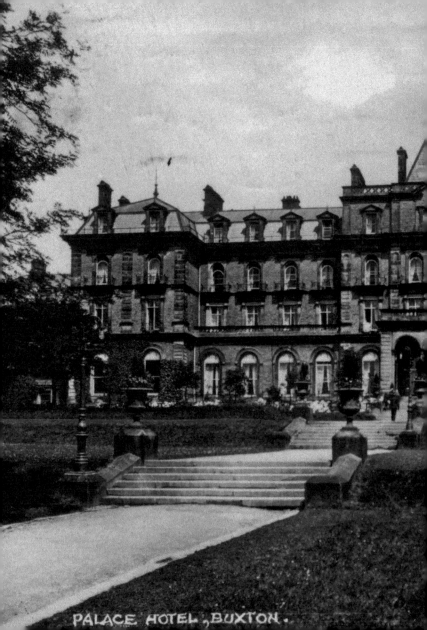

PALACE HOTEL, BUXTON.

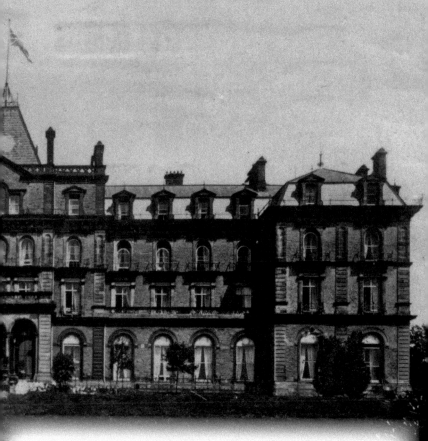

20. PALACE HOTEL

The Palace Hotel is located just across the road from the railway stations. When built in 1867, it was called the Buxton Hotel but was renamed as the Palace Hotel in 1868. This was shortly after the opening of the railway links which resulted in a major increase in visitor numbers to the town. It continues to thrive today with its health club and spa facilities and a steady flow of special events.

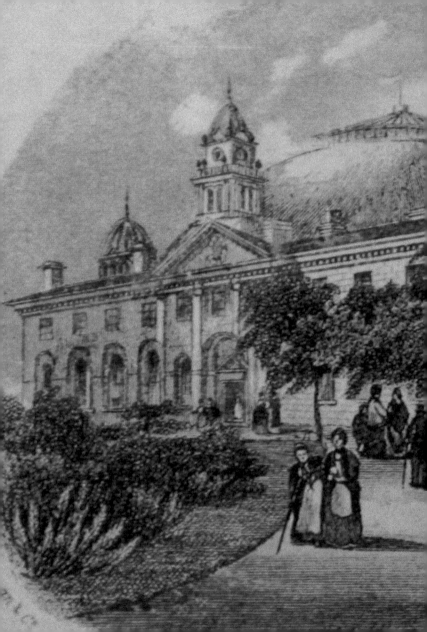

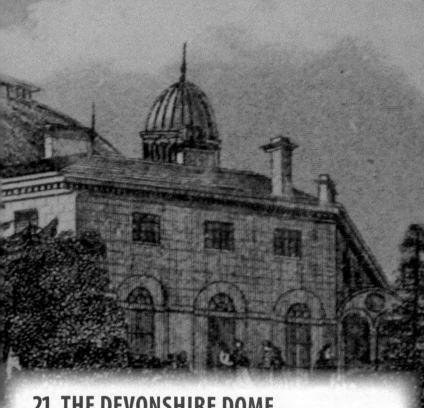

21. THE DEVONSHIRE DOME

This building has a long and varied history. It started life as the stables building for the Crescent with stables, spaces for coaches and accommodation for the associated staff. In 1859, part of the stables were converted to provide convalescent treatment for cotton workers and then the whole building was progressively converted to hospital use, specialising in orthopaedic and rheumatic problems. The huge central dome was constructed in 1881 to provide a covered area where patients could take exercise.

22. THE DOME INTERIOR

The photo shows the huge interior of the dome, at one time regarded as the largest unsupported dome in Europe, with a statue of the Duke of Devonshire. The hospital closed in 2002 and, after extensive renovation, the building was officially opened as a campus of the University of Derby by the Prince of Wales in 2006.

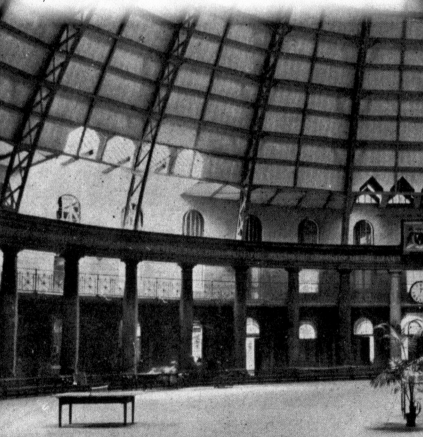

Devonshire Hospital, Buxton.

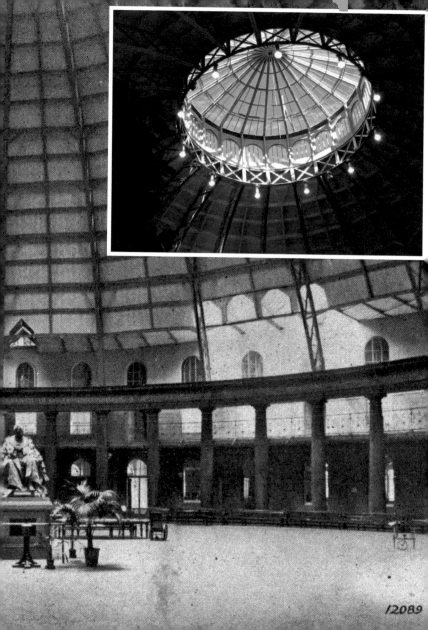

12089

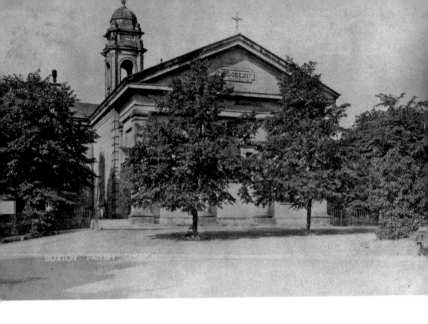

BUXTON PARISH CHURCH

23. ST JOHN'S CHURCH

St John's Church was built in 1811 to serve the religious needs of the growing number of visitors and residents in the general area of the Crescent. At that time, Buxton's church was St Anne's at the further end of Higher Buxton, some distance from the developing fashionable spa.

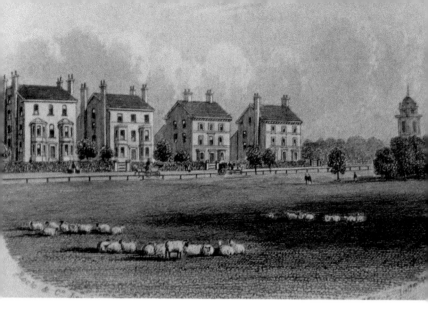

24. MACCLESFIELD NEW ROAD

In 1821, a new Buxton to Macclesfield road was built to replace the existing road, which had many severe gradients. This road began at St John's Church, passed through the village of Burbage and across the hills on a more evenly graded route. It became well known for the Cat and Fiddle Inn at its highest point.

25. AERIAL VIEW OF PARK ROAD

The building of the Macclesfield New Road, now called St John's Road as far as Burbage, opened up a large area of land for further development and Joseph Paxton planned a layout for one part of this land. The open area between the new road and the Manchester Road was developed as the Park where a circular loop of road enclosed an area for a cricket ground, with four short access roads from the existing roads. Large individual plots of land were sold for private development, but all new buildings had to be of an imposing size. One access road is a short distance up Manchester Road from St John's Church.

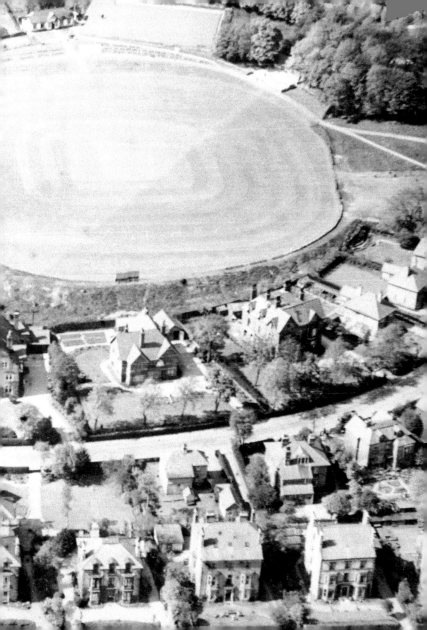

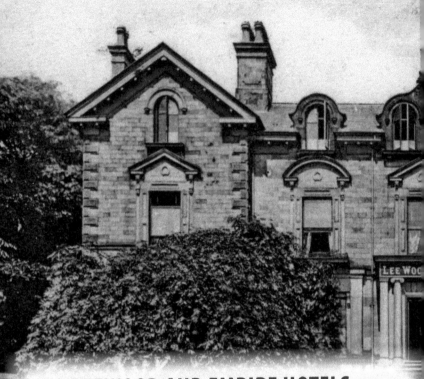

26. LEEWOOD AND EMPIRE HOTELS

Most plots of land were used for the construction of villas around the park but two hotels were also built. The Leewood Hotel was built on an imposing site on the high ground at the Manchester Road side of the park with extensive views across Buxton. The hotel remains a popular meeting place for local societies and festival events in addition to its residential business. The Empire Hotel was the largest hotel built in Buxton. It was also located on the high ground of the park with extensive views across the town. It opened in 1903. It was used as a military hospital during the First World War but never reopened as a hotel. It was demolished in 1964.

e Wood Hot

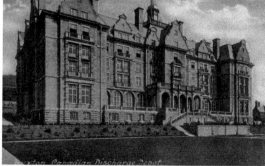

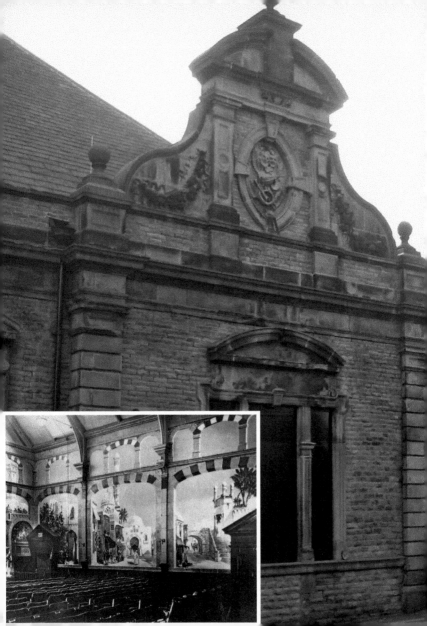

27. PAVILION ARTS CENTRE

Returning to St John's Church takes one to the oldest surviving theatre building in Buxton, built in 1889. Known at various times as the New Theatre, the Hippodrome and the Playhouse, the building is now known as the Pavilion Arts Centre. It is now used as a multipurpose centre for smaller-scale dramas and concerts, rehearsal space and lecture theatre. Recently, the Buxton Cinema was set up there with a varied monthly programme.

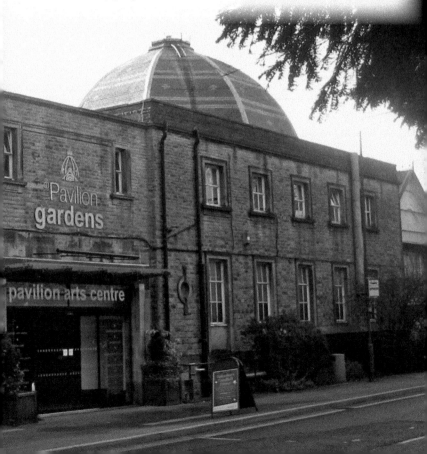

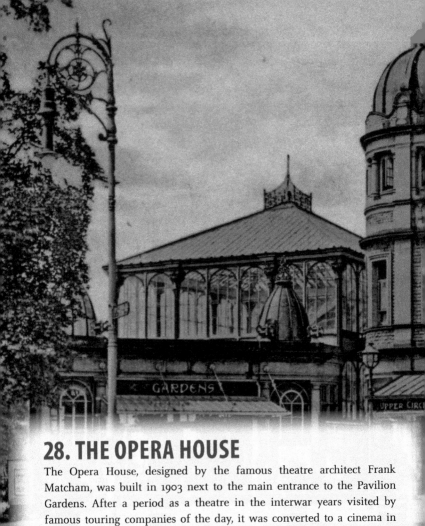

28. THE OPERA HOUSE

The Opera House, designed by the famous theatre architect Frank Matcham, was built in 1903 next to the main entrance to the Pavilion Gardens. After a period as a theatre in the interwar years visited by famous touring companies of the day, it was converted to a cinema in 1927 but this closed in 1976. It was reopened as a theatre in 1979 after a partial restoration project and the highly successful Buxton International Festival began later that year.

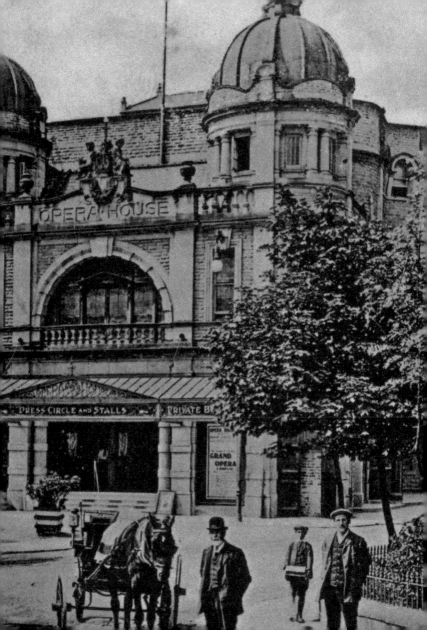

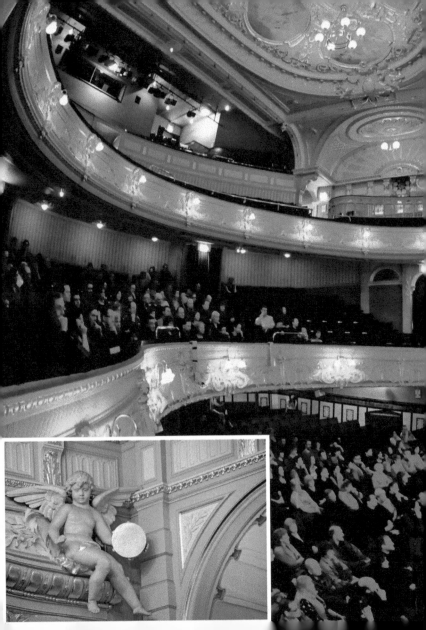

29. OPERA HOUSE INTERIOR

The interior of the Opera House is richly decorated in an Edwardian style with hints of art deco. In addition to the annual Opera Festival with its associated Literary Festival and Festival Fringe, which go from strength to strength, it hosts numerous touring drama, comedy and musical productions, totalling over 400 performances per year. A further major restoration of the internal decorations and the external structure took place in 1999–2001. The central decoration in the ceiling of the auditorium was carefully restored and other decorations were re-gilded under the watchful gaze of the cherubs. The theatre interior ranks as one of the finest examples of Matcham's work in the country.

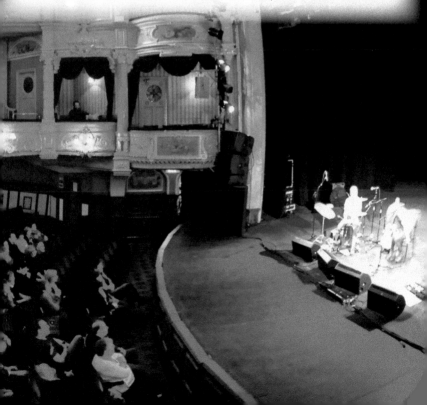

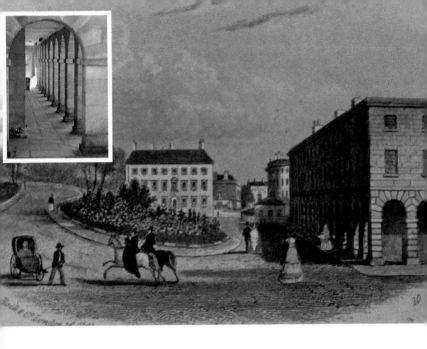

30. THE SQUARE

Opposite the Opera House is a block of apartments commissioned by the Duke of Devonshire and built in 1803–06, to provide extra accommodation for visitors to the developing spa. This block, known as the Square, has stone arched colonnades along two sides. Because of the lack of space in the narrow Wye Valley, the Square was built across the river. The George Inn (to the left of the Square) was built on the original line of the Manchester turnpike in the 1770s. This road was diverted to the Terrace Road/Quadrant line to enable the Crescent to be built.

31. OLD COURT HOUSE

This set of buildings is located at the back of the Crescent. Dating from the mid-nineteenth century, these buildings have at various times housed council offices, courtroom and Oram's car showrooms. More recently, it has housed a variety of small shops catering for visitors. It now houses four restaurants and bars ranging from French bistro to Buxton beer and gin to Tex/Mex.

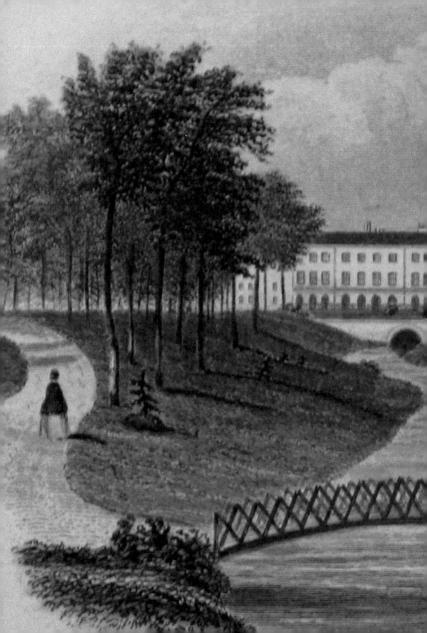

32. PROMENADES AND RUSTIC BRIDGES

In the first half of the nineteenth century, the Old Hall and the Square looked out on to a large open space across which flowed two branches of the River Wye. Some of the area close to the Old Hall was laid out as a formal garden and by the banks of the rivers formal paths had been laid and trees had been planted. Some rustic bridges had been made to enhance the interest of riverside walks. This picture from 1854 shows the Square and the waterfall leading to the culvert which took the Wye beneath the buildings; the second branch of the Wye is shown joining the main branch at the front of the picture.

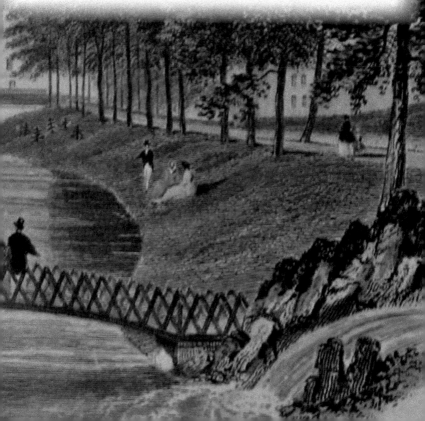

33. THE PAVILION GARDENS

The Pavilion Gardens, a 23-acre landscaped open space and a complex of buildings in cast iron and glass, were first opened on 12 acres of this site in 1871. The gardens were extended to their present size in 1876. Originally, there was an admission charge to the gardens and an entry point, close to where the Opera House now stands. This view, from 1876, shows the main building and some of the features added since the earlier view, including a lake formed on the smaller branch of the Wye.

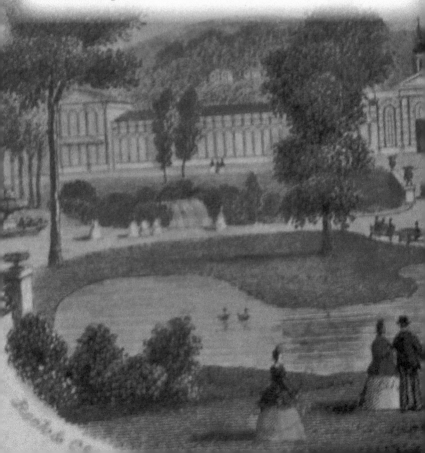

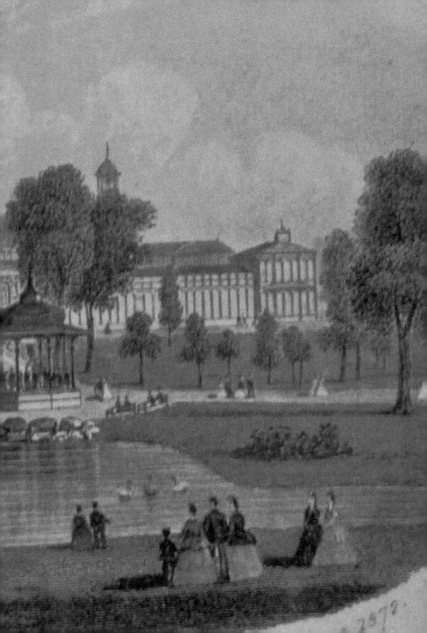

34. PAVILION GARDENS BUILDINGS

The original building had a large central hall and a symmetrical pair of extensions, giving the long frontage shown in the picture. There have been several changes to the buildings over the years as the Octagon, Playhouse and Opera House have been added. The large central hall remains relatively unchanged externally. It was rebuilt in 1983 after a serious fire and it is now a two-level restaurant and coffee lounge. The wing to the left houses a shop featuring local produce and the Gallery in the Gardens, a show place for local works of art – paintings, pottery, embroidery. The other wing was replaced in a similar form of construction when the Opera House was built. It was arranged in 1982 into its present layout as a conservatory, with a wall displaying spectacular aerial photos of the Peak District.

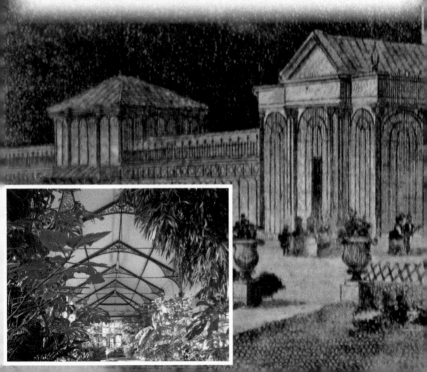

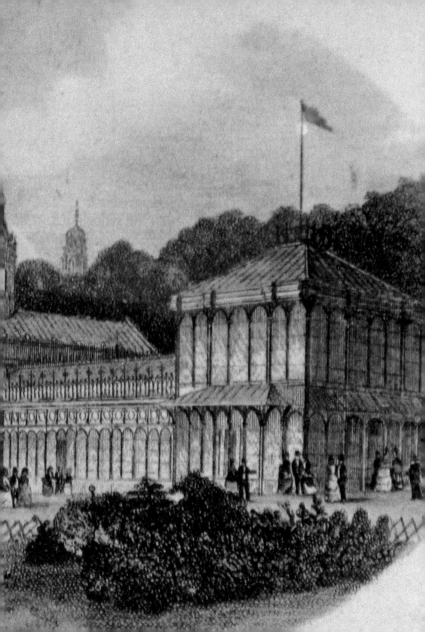

35. THE OCTAGON

The most prominent of the cast-iron and glass buildings in the Pavilion Gardens complex is the Octagon, constructed in 1876. It provides a large indoor space for antique fairs, farmers markets, tea dances, concerts and a variety of other activities. As a concert hall, it has room for an audience of 800. In addition to the buildings, the wide Parade in front of the buildings was a popular spot for relaxation and refreshment.

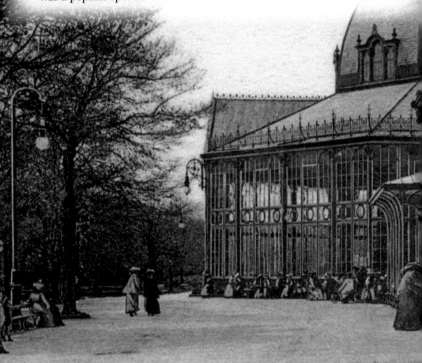

The Pavilion

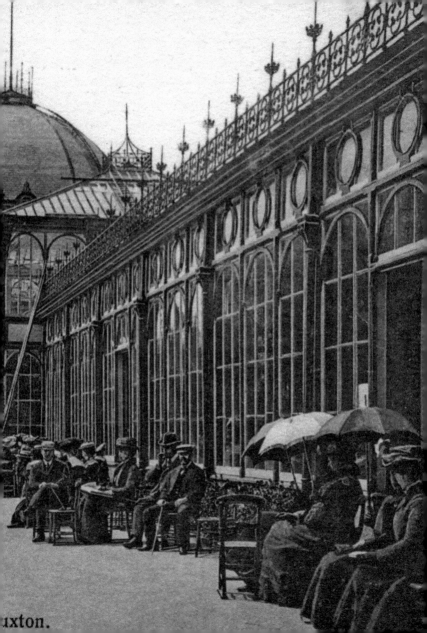

uxton.

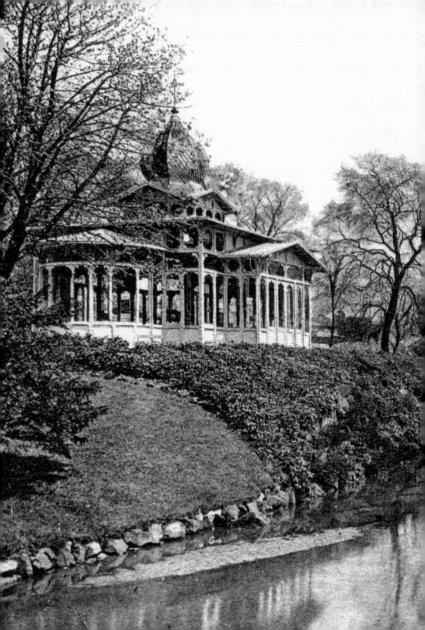

36. BANDSTANDS AND URNS

As well as the main buildings there have been other small buildings and bridges in a similar style in the gardens. The picture shows a modern bandstand built in 1998 in the traditional style, on the base of a previous structure – a regular venue for band concerts and weddings. Other bridges and decorative urns were built as features of the landscape.

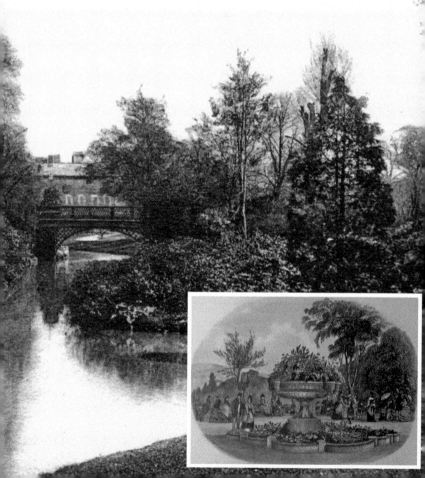

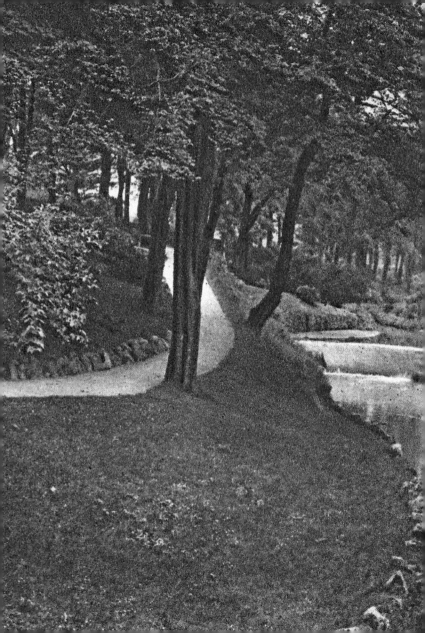

37. THE SERPENTINE WALKS

Continuing along the paths by the main branch of the river takes you on to Burlington Road and across the road are the Serpentine Walks. The walks shown in the picture at location 33 extended beyond the area taken over by the Pavilion Gardens and the stretch shown in this picture continues to offer a shady rustic walk with picturesque waterfalls. They were called the Serpentine Walks because they followed the numerous bends in the rivers.

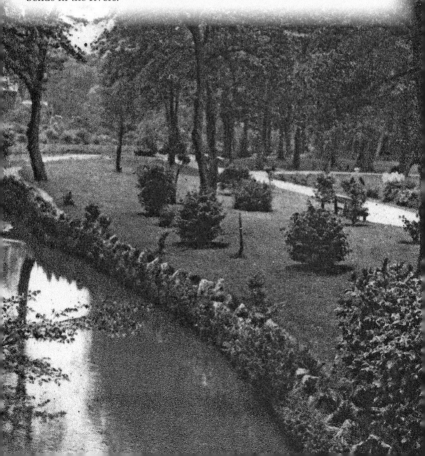

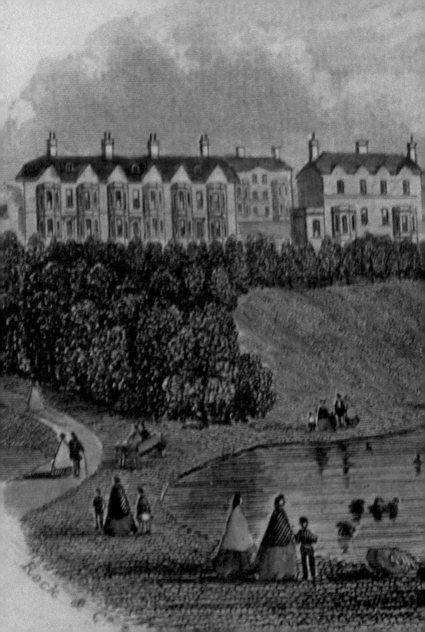

38. BROAD WALK

Returning to the Pavilion Gardens and making one's way across the park, past the various play areas takes one to the upper lake, fed by the branch of the Wye that flows under Grin Low and through Poole's Cavern. Beyond the lake is Broad Walk, a pedestrian terrace along one side of the Pavilion Gardens, originally fringed by detached villas and small hotels. The lake is a boating lake and there is a landing stage. At the end of Broad Walk, several roads meet with Bath Road up the hill to the left and Temple Road across the road junction leading uphill towards the woods.

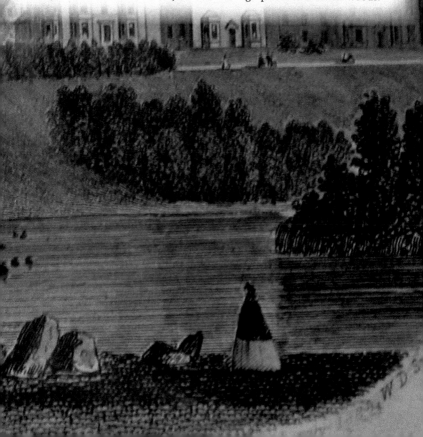

39. POOLE'S CAVERN

Temple Road leads to Poole's Cavern, an important visitor attraction with a car park, Visitors' Centre, Go Ape, access to Grinlow Woods and the cavern itself. Grin Low is a large limestone hill and Poole's Cavern is an extensive cave system formed by erosion from past water flows. A stream still flows there, which emerges around half a mile away at Wye Head and flows on to the Pavilion Gardens. From the seventeenth century onwards, it was included as one of the 'Seven Wonders of the Peak' in the guidebooks. The cavern and woods are owned by the Buxton Civic Association.

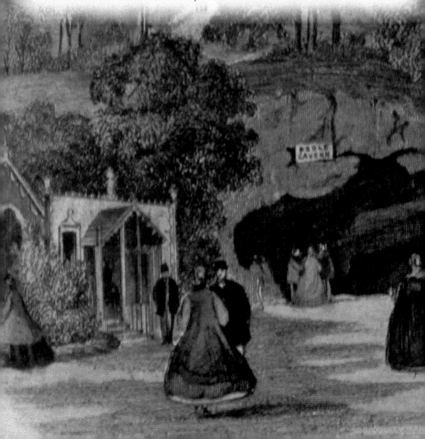

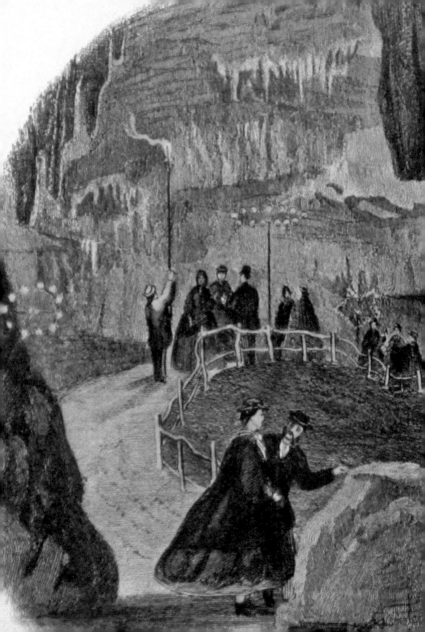

40. INSIDE THE CAVERN

The cave has been used over many centuries as a shelter or hiding place. In the mid-nineteenth century, the cave was illuminated by gaslight and it became very popular with visitors. Modernised with electric lighting in the 1960s, it is now illuminated by modern LED lighting with a fascinating variety of colours. The cave has an impressive array of stalactites and stalagmites and there are regular guided tours. There is also a good interpretation display in the Visitors' Centre.

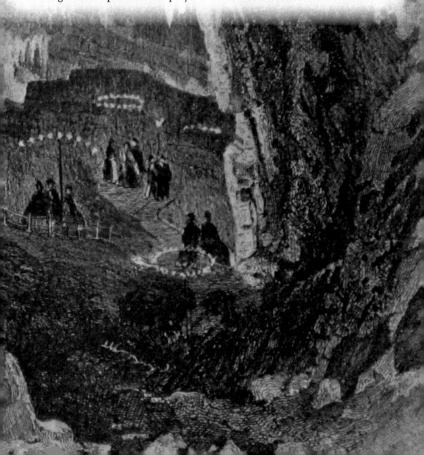

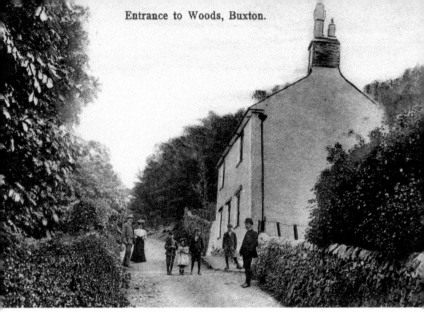

41. GRIN LOW WOODS

The hill known as Grin Low was extensively covered by small limestone quarries and limekilns until the early nineteenth century when extensive tree planting took place – a very early example of environmental regeneration. The woods are now popular for walking, with an extensive range of trees and native plants. Some areas are maintained as open glades and the different soil composition created by lime-burning residues encourages a wide variety of wild flowers. The woods form part of the Buxton Country Park and they have been designated as a Site of Special Scientific Interest.

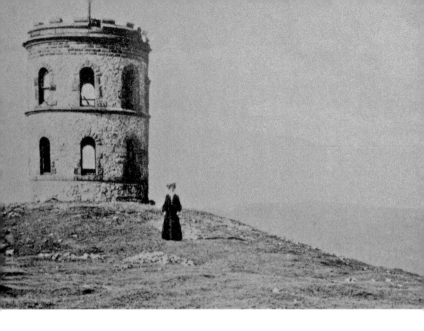

42. SOLOMON'S TEMPLE

Grin Low Tower was built by Solomon Mycock in 1896 and is generally known as Solomon's Temple. It stands on the highest point of Grin Low, at 1,434 feet, and has extensive views in all directions. In particular, it gives a panoramic view of the town nestled in the valley below. The tower was built on an ancient burial mound and several Bronze Age skeletons and some Roman items were discovered when the tower was built.

43. ST ANNE'S CHURCH

Returning along Temple Road and up Bath Road takes one to St Anne's Church. The earliest recorded date for a chapel in Buxton is 1489 but there may have been one at an earlier date. The present St Anne's Church has a font with the carved date of 1625, although it is of Norman design. It was extensively restored in 1956–57. The top of Bath Road leads into the High Street.

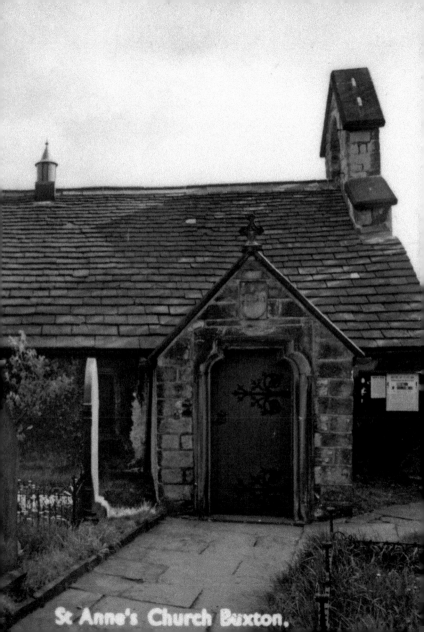

St Anne's Church Buxton.

44. HIGH STREET INNS

The Market Place/High Street area was the original location of Buxton village and there is a cluster of five public houses within two minutes' walk of the church. These date from the era of horse-drawn traffic and several still have their stable yards, which catered for local trade rather than the spa visitors. As a sign of the times, the Baker's Arms, just below the church, closed some years ago and was converted into houses; the other inns remain in business.

45. MARKET PLACE

This picture shows the Market Place, looking south towards the High Street with Solomon's Temple and Grin Low in view on the horizon. The lower buildings on the right include some small shops and a school, leading on to the Eagle Hotel with the Methodist church beyond. The row of smaller buildings was replaced by a terrace of three-storey buildings known as Eagle Parade in the late nineteenth century. This area was the main route through the area as far back as Roman times. Markets take place on Tuesdays and Saturdays.

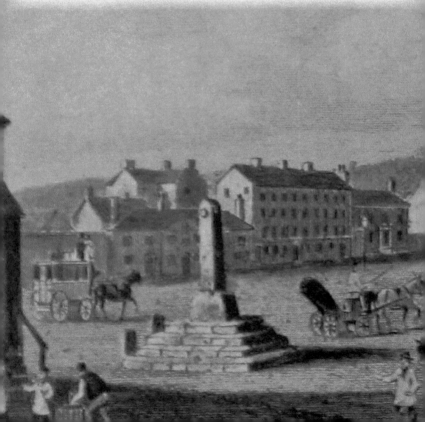

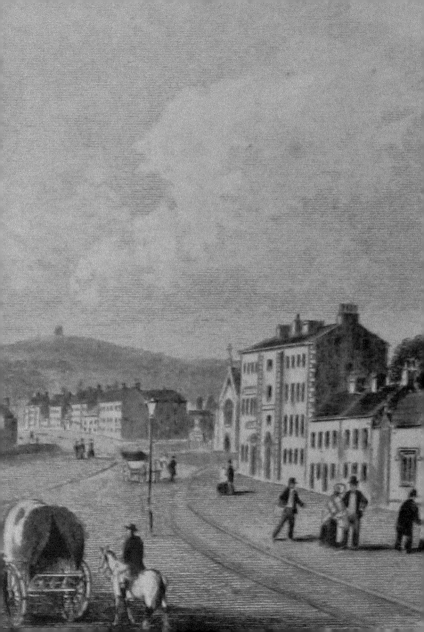

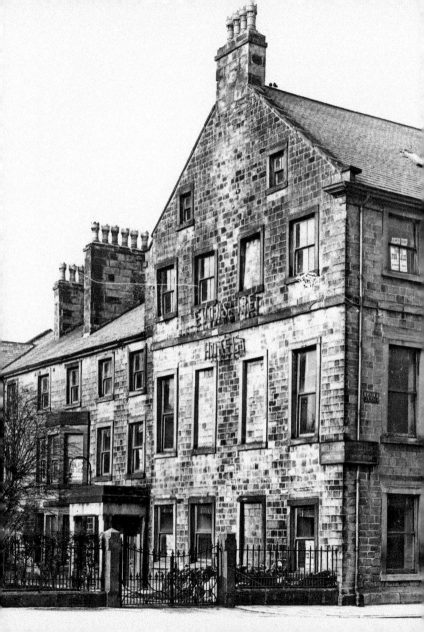

46. EAGLE HOTEL

There was an inn known as the Eagle and Child recorded in 1592. The Eagle Hotel is thought to be on the same site; it was rebuilt in 1760. There was extensive stabling to one side of the building for travellers in coaches and carriages. It has seen many changes over the years and is currently an inn, apartments and the home of several local businesses. The stabling has been rebuilt for a variety of uses.

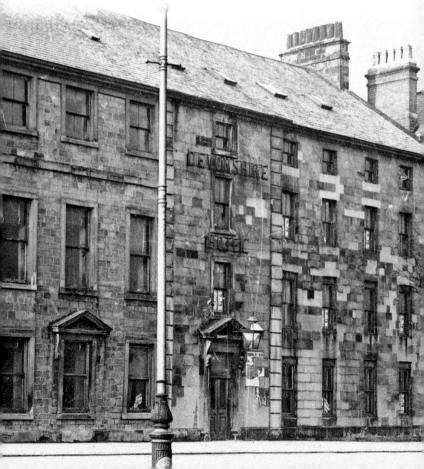

47. TOWN HALL

The Town Hall was built at the northern end of the Market Place on a fine site with extensive views front and rear. The site was previously occupied by a market hall which was destroyed by fire in 1885. The Town Hall was built fronting onto the Market Place with a tall central clock tower. The other side of the building looks onto the Slopes with a fine avenue of mature trees leading up to it, with a French chateau effect. To the left of the Town Hall is Hall Bank, a steep road with houses built mainly in the 1800s, which was the original route of the main road through the town. To the right is Terrace Road, which is now the through route, constructed at the same time as the Crescent to keep traffic away from this prestige development.

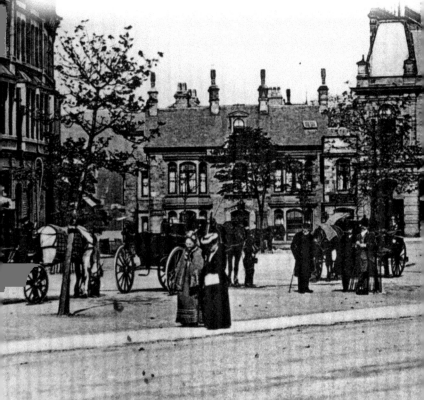

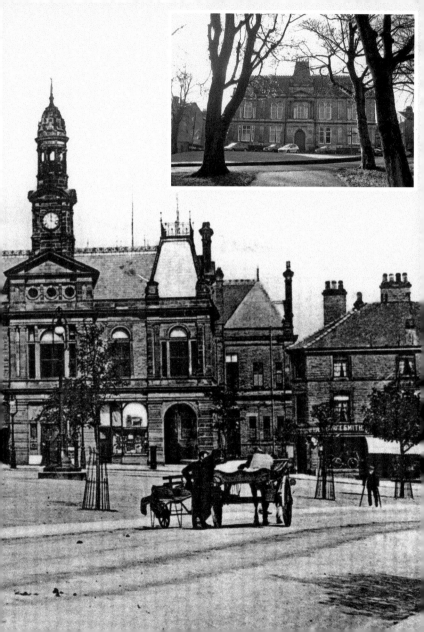

48. BUXTON MUSEUM

As Buxton developed as a spa resort, several large hotels and hydropathic establishments were built in the town. The Peak Hydropathic Establishment was built in 1870 at the top of Terrace Road, opposite the Town Hall. This extensive building now houses the Buxton Museum and Art Gallery, with good local displays and several large display rooms for exhibitions, and the Green Man Gallery, home to displays of paintings and craft creations by local artists. The Museum displays cover a timeline of developments and changes in Buxton and the Peak District from the Neolithic age through to the twentieth century.

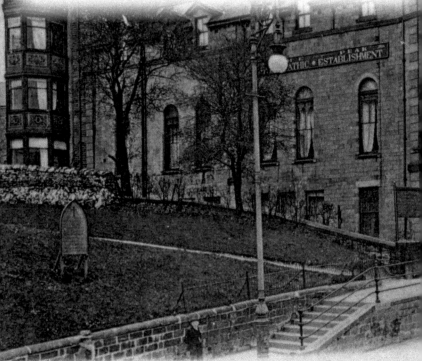

The Peak Hydropathic Establishment

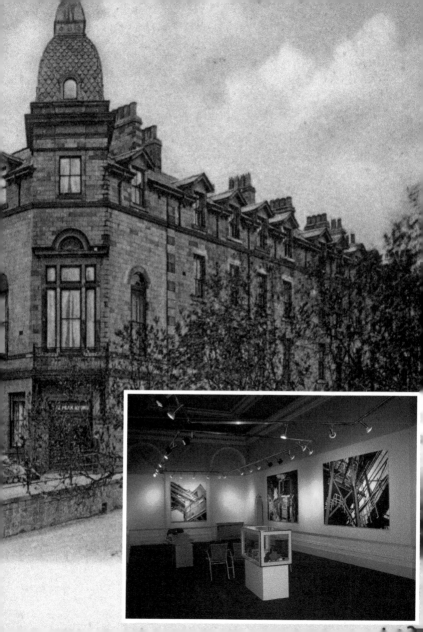

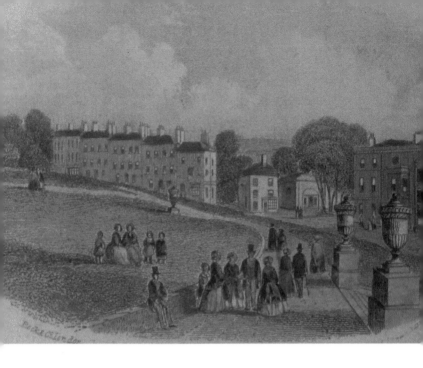

49. THE SLOPES

The Slopes is a landscaped area of paths and trees on the sloping ground between the Crescent, Terrace Road, Hall Bank and the Town Hall. It was laid out as an area for visitors to the Crescent to promenade, originally fenced off from the general public. Accessed from the car-parking area behind the Town Hall, it provides a relaxing end to the History Tour with a choice of paths winding their way down the hill, each with their own panoramic view of many of the locations previously visited, back to the starting point at the Old Hall Hotel.